Adult and Teen Coloring Book

Beautiful Beads 1

Marigold Fairchild

Stress Relieving Patterns and Designs

Copyright © 2018 Marigold Fairchild

All rights reserved. No part of this publication may be reproduced, distributed or transmitted in any form or by any means, including photocopying, recording or other electronic or mechanical methods, without the prior written permission of the author.

ISBN-13: 9781792129605
Imprint: Independently published

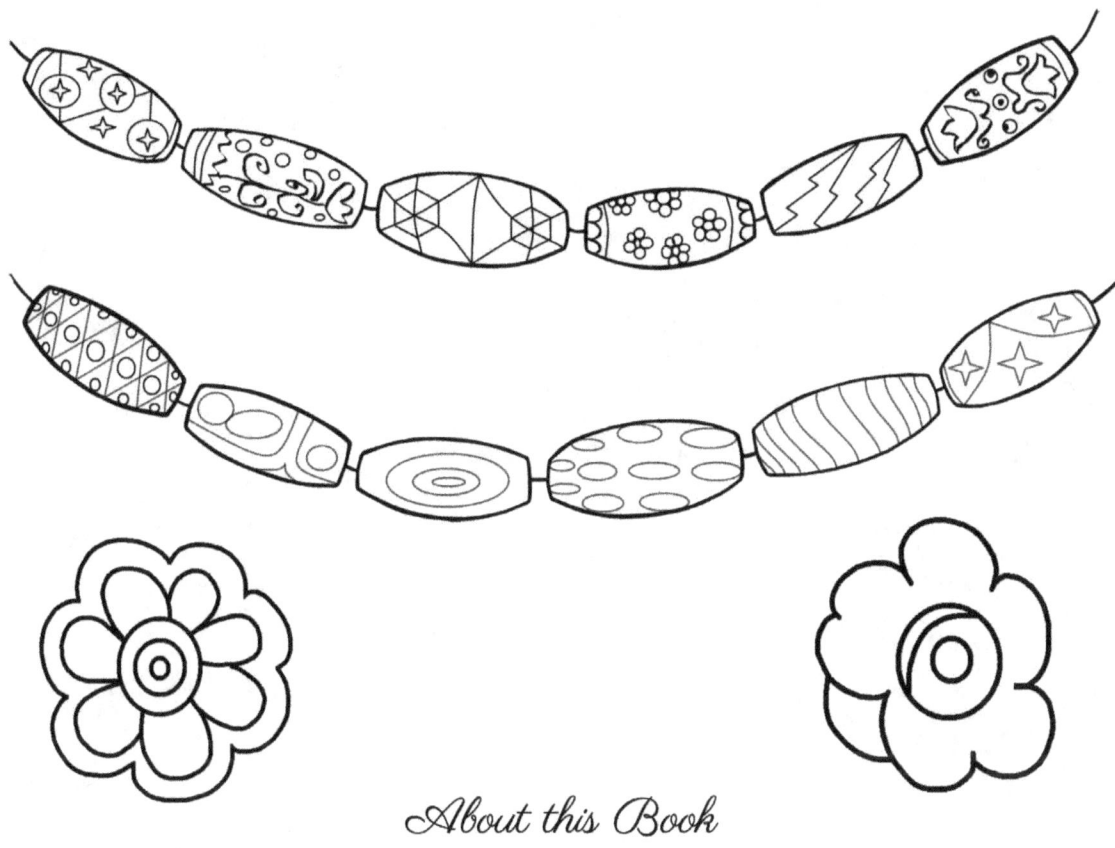

About this Book

Thank you for purchasing this Book. Beautiful Beads 1 is a coloring book, suitable for adults and teens. Inside you will find 24 pages of Beautiful Beads tastefully presented, in a huge variety of designs and lovely patterns. The drawings are mostly handmade, and not computer generated, so that they are artistic, attractive and interesting enough. Each project is entertaining, a bit challenging, but not extremely complicated, so that they are not overwhelming to complete, in difficulty or in time.

Coloring is great, as a relaxing therapy for stress relief, to develop patience, improve attention or simply to allow yourself to express your inner artist. So be are guest and have fun to your heart content.

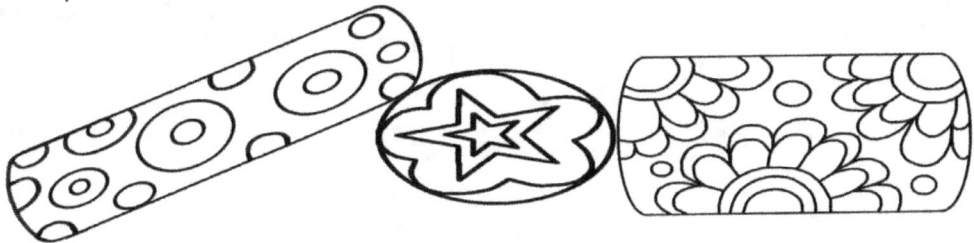

Coloring Tips

You will find that the pages are printed on one side only. But please be aware that by the moment, as self-publishers, we don't have the choice to choose the paper thickness or to ask for perforated pages, so the pages are not removable. Even then, we left plenty of space at the binding, so you can cut the pages out with a ruler and a blade, or even with a scissor.

If you are using markers or gel pens, don't forget to place a scrap piece of paper behind the page that you are coloring, so the colors won't bleed through the next page. For this reason, we included some Blotting pages at the end of the book, which you can cut or tear out, and use them as scrap paper, whenever you are using a wetter media.

Before you start coloring, we recommend trying out your pens, markers, pencils or crayons, on the Color test page, so you can be absolutely sure of the results you will obtain. Use the Color test page, to decide what colors you want to combine, and also to acknowledge, how hard you can go on the paper with each media. On areas already colored, where you can't avoid laying your hand on, you can use a paper towel under your hand, to avoid color transfer and smearing.

Color Combinations

We think that there is not a correct way of coloring Beads. You can combine complementary colors or just different shades of the same color; use one color only, meanwhile leaving some spaces in white; go bold with primary and secondary colors or soft with pastels; stick to warm or cool colors; use all colors or just your favourite ones. So feel free to make your choice and follow your own taste.

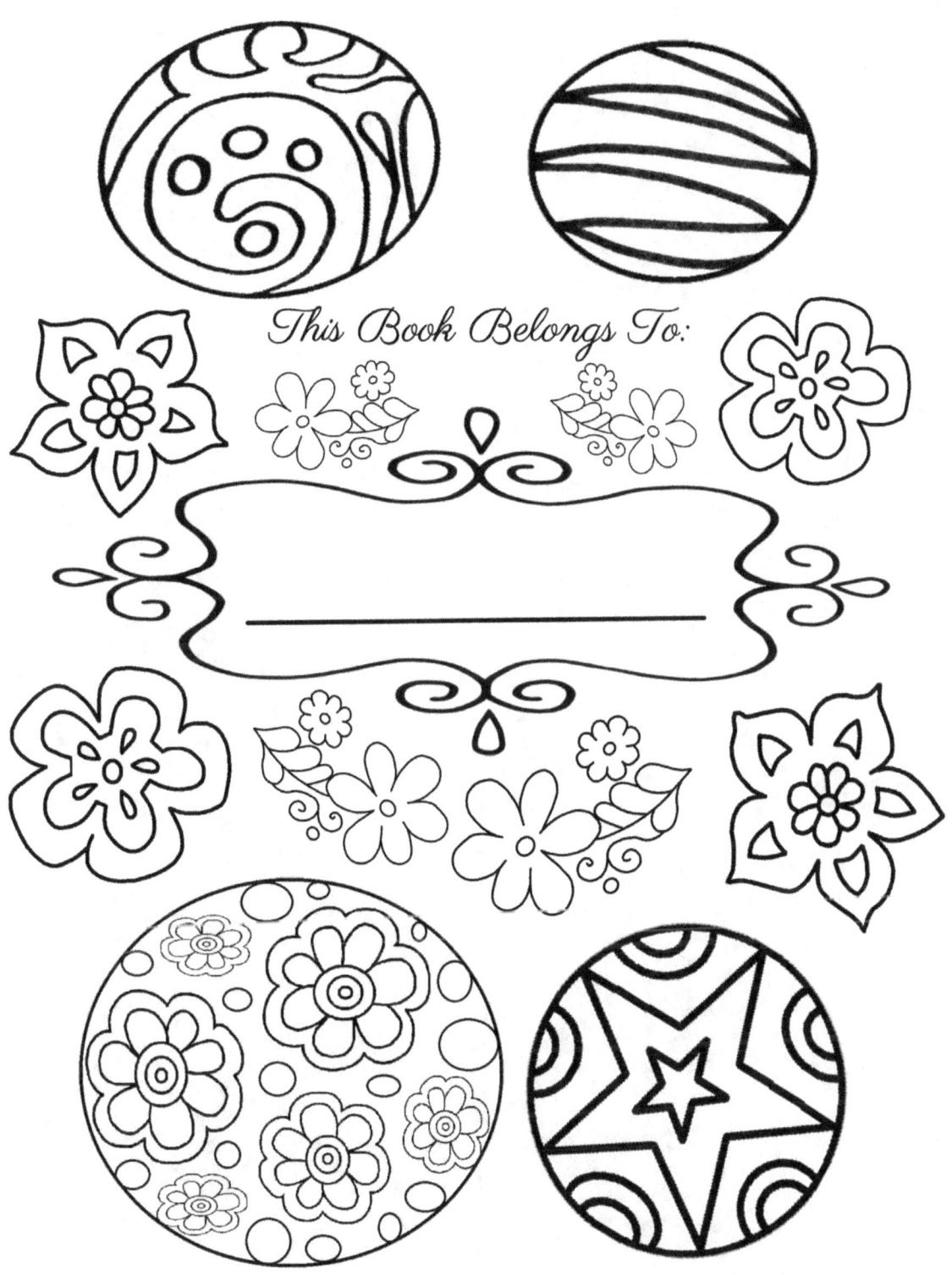

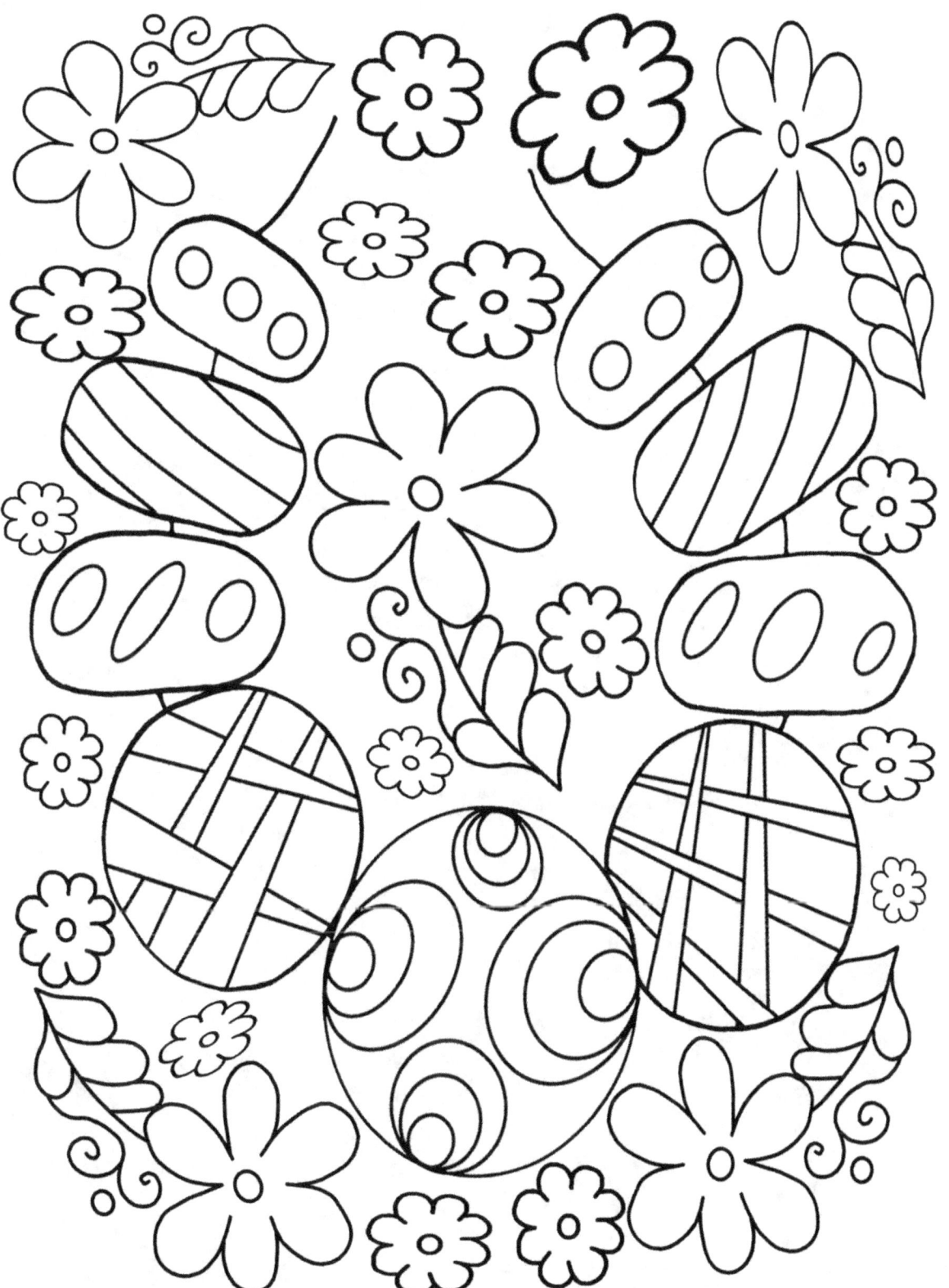

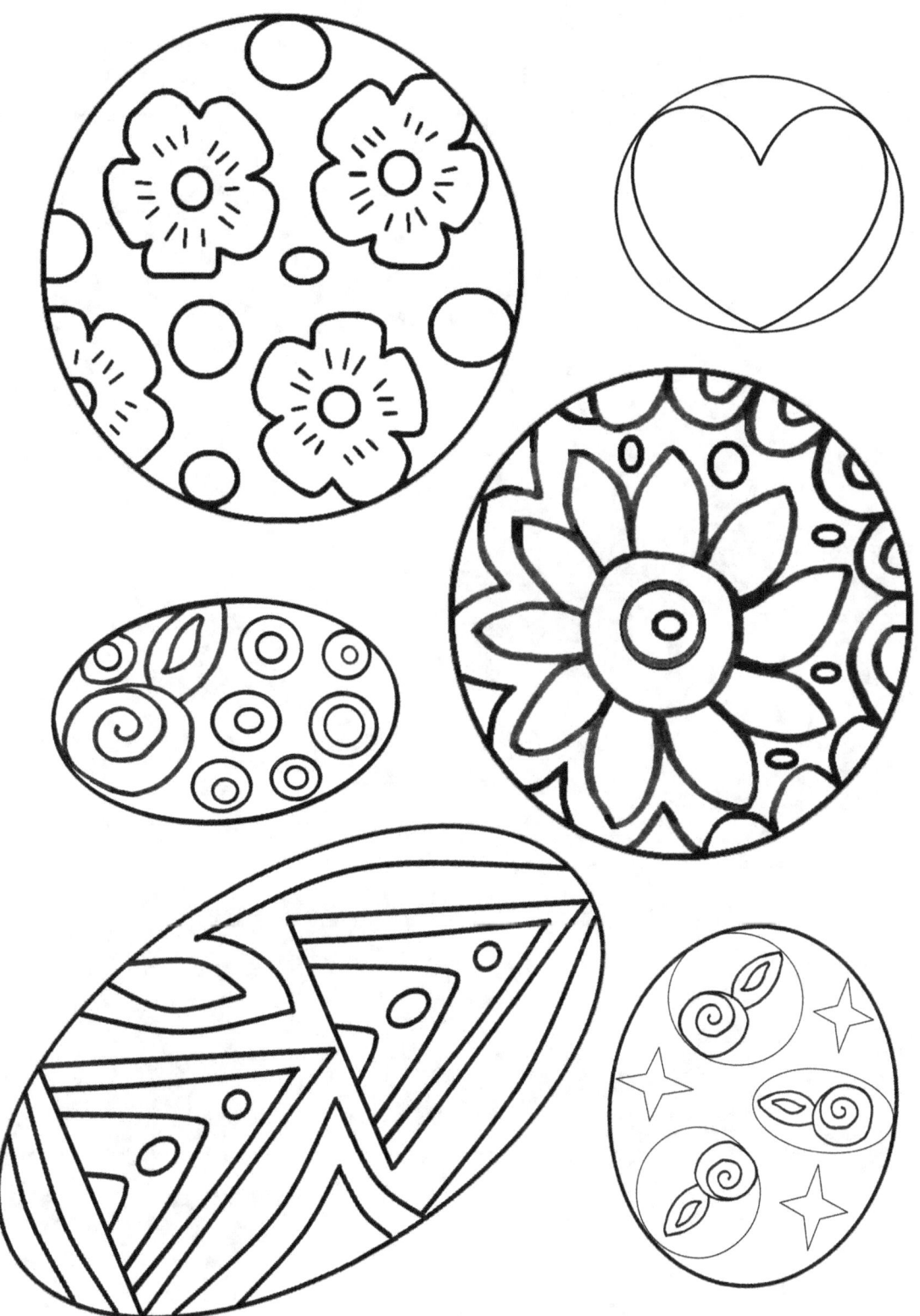

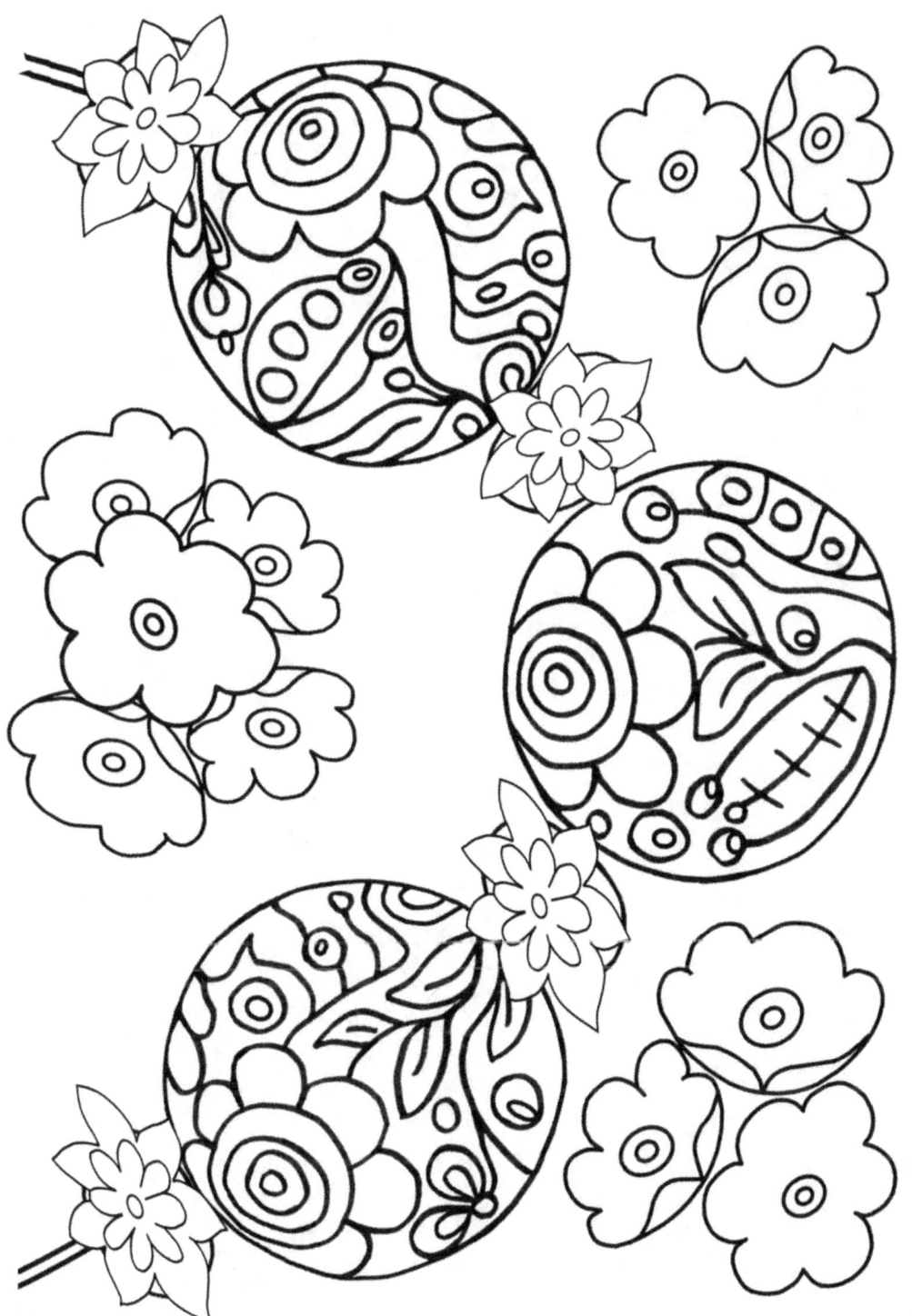

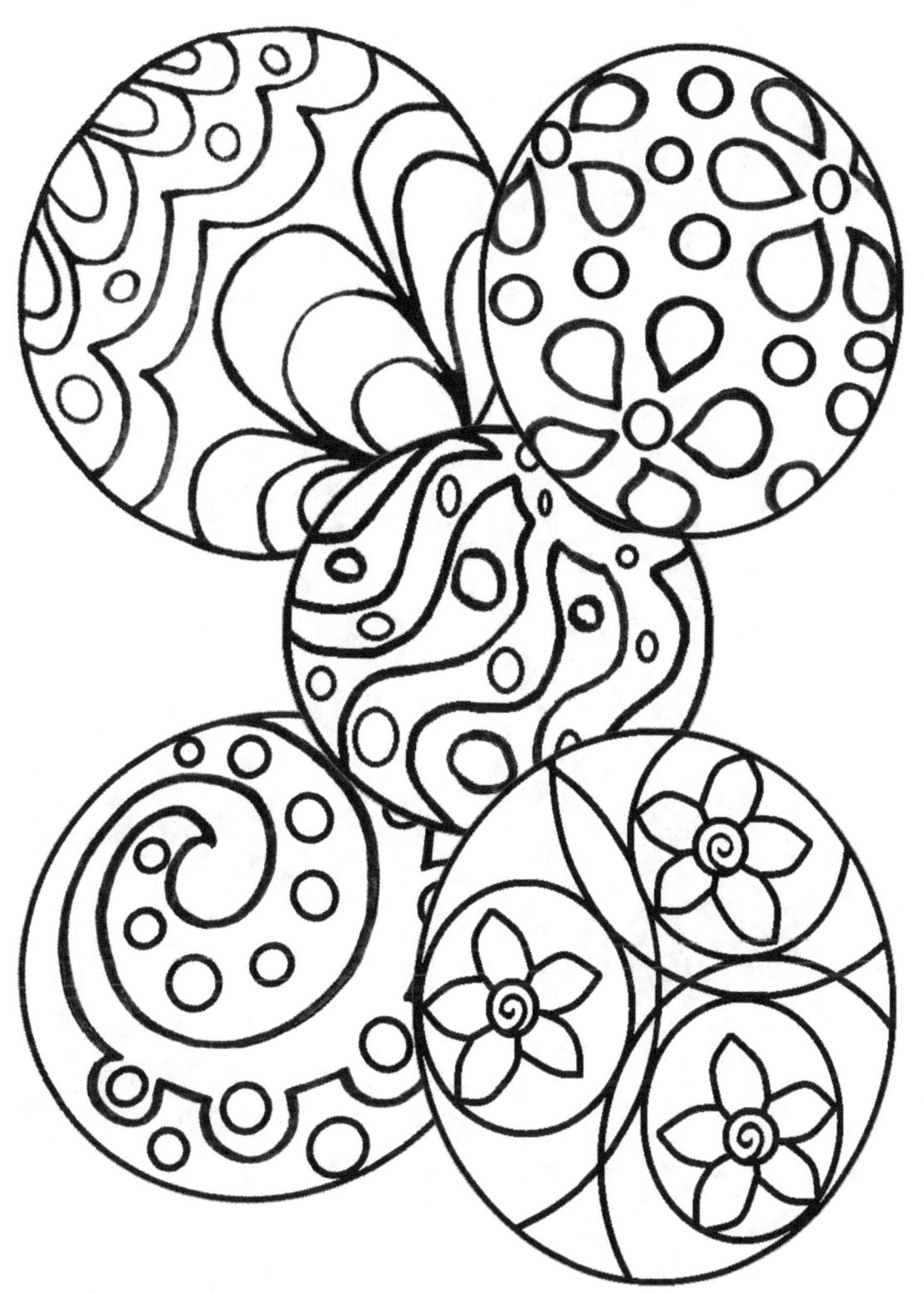

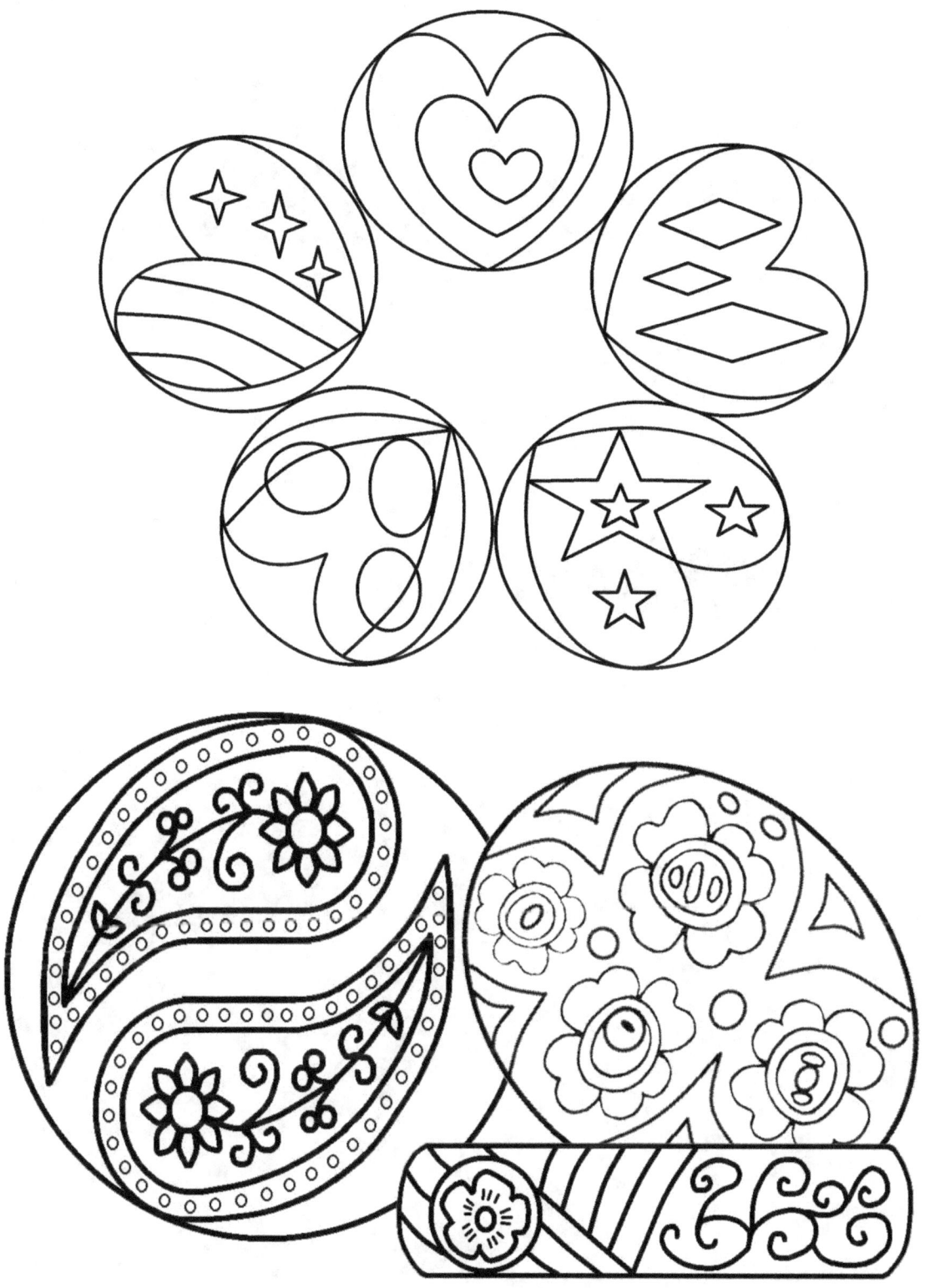

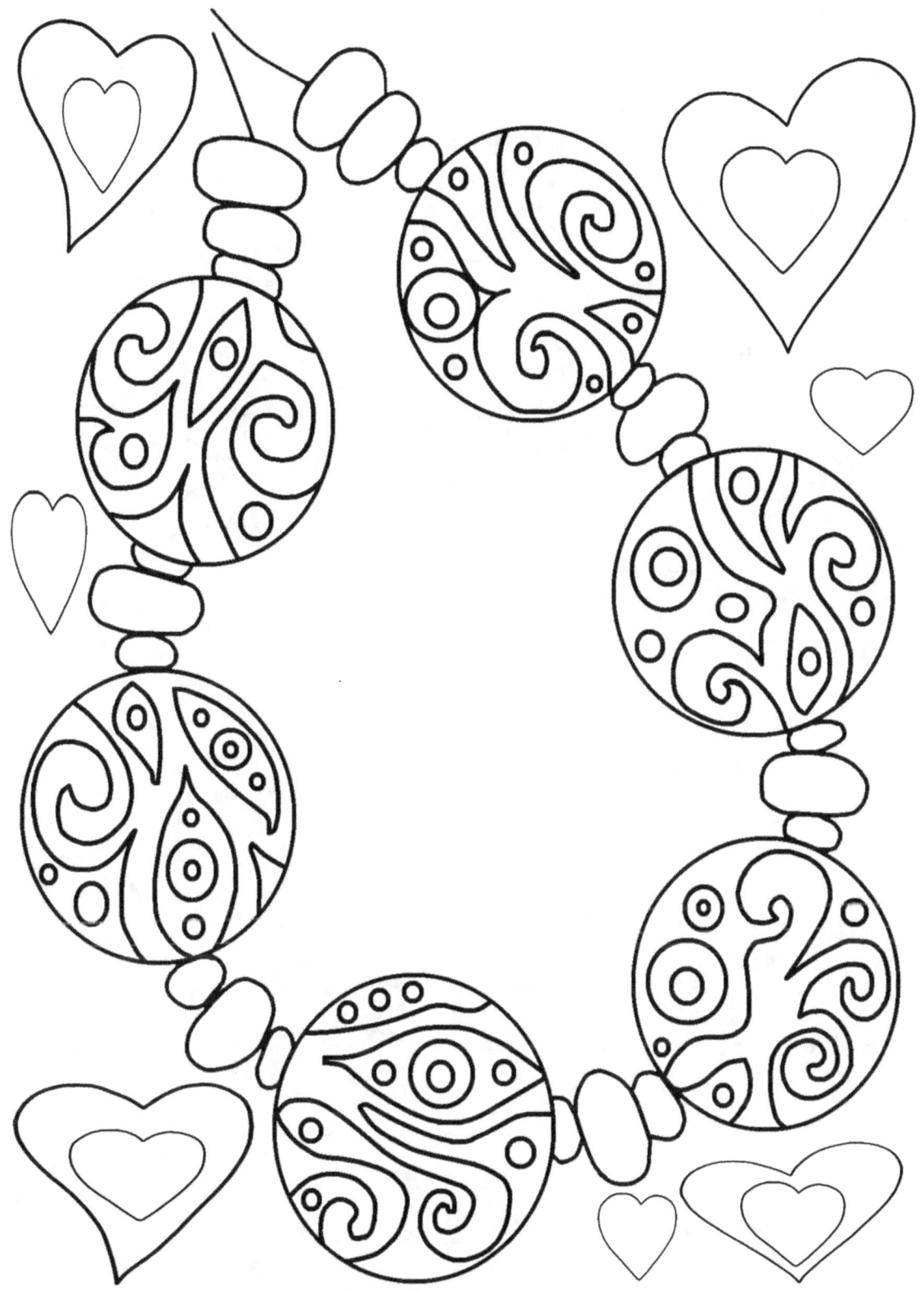

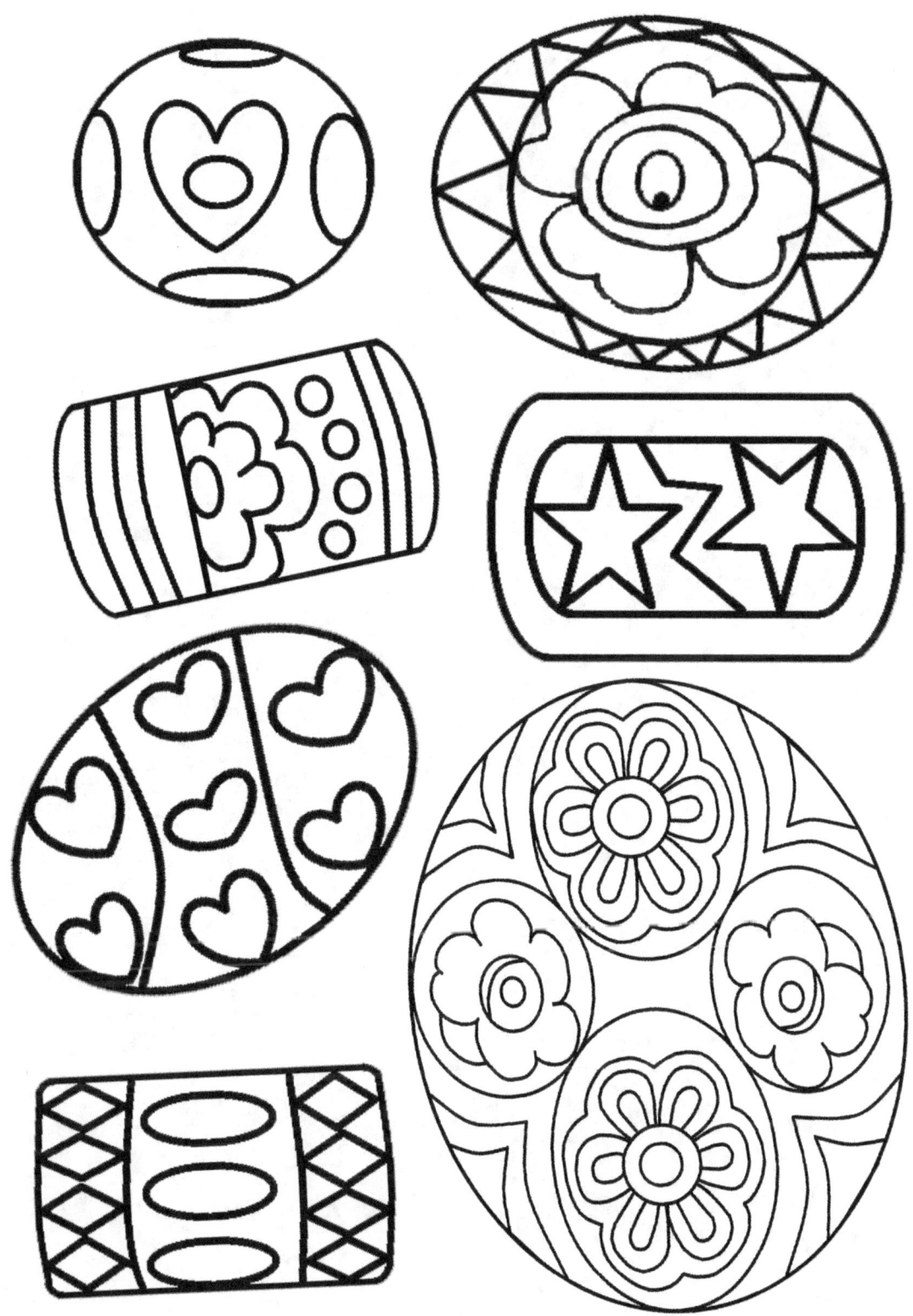

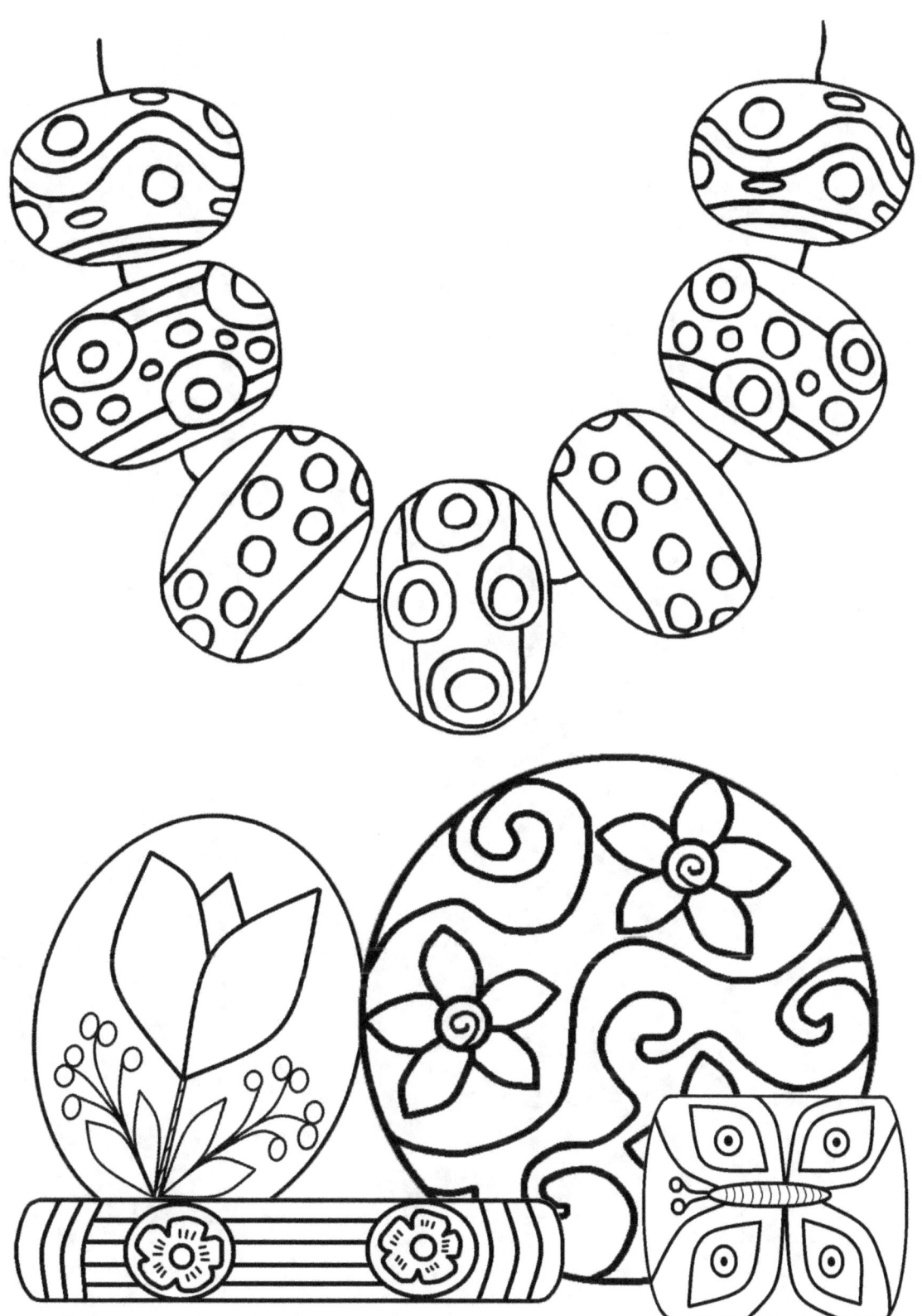

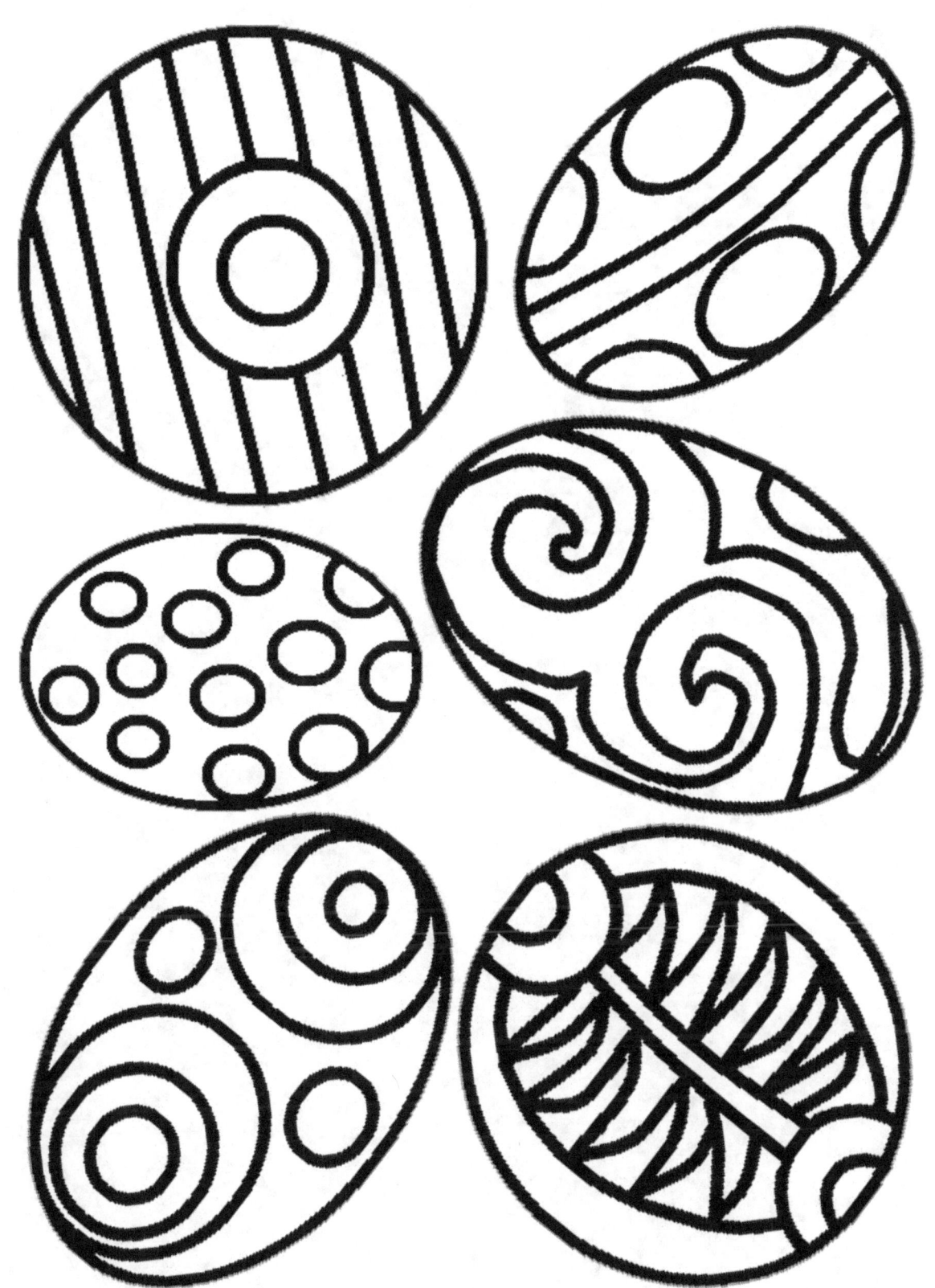

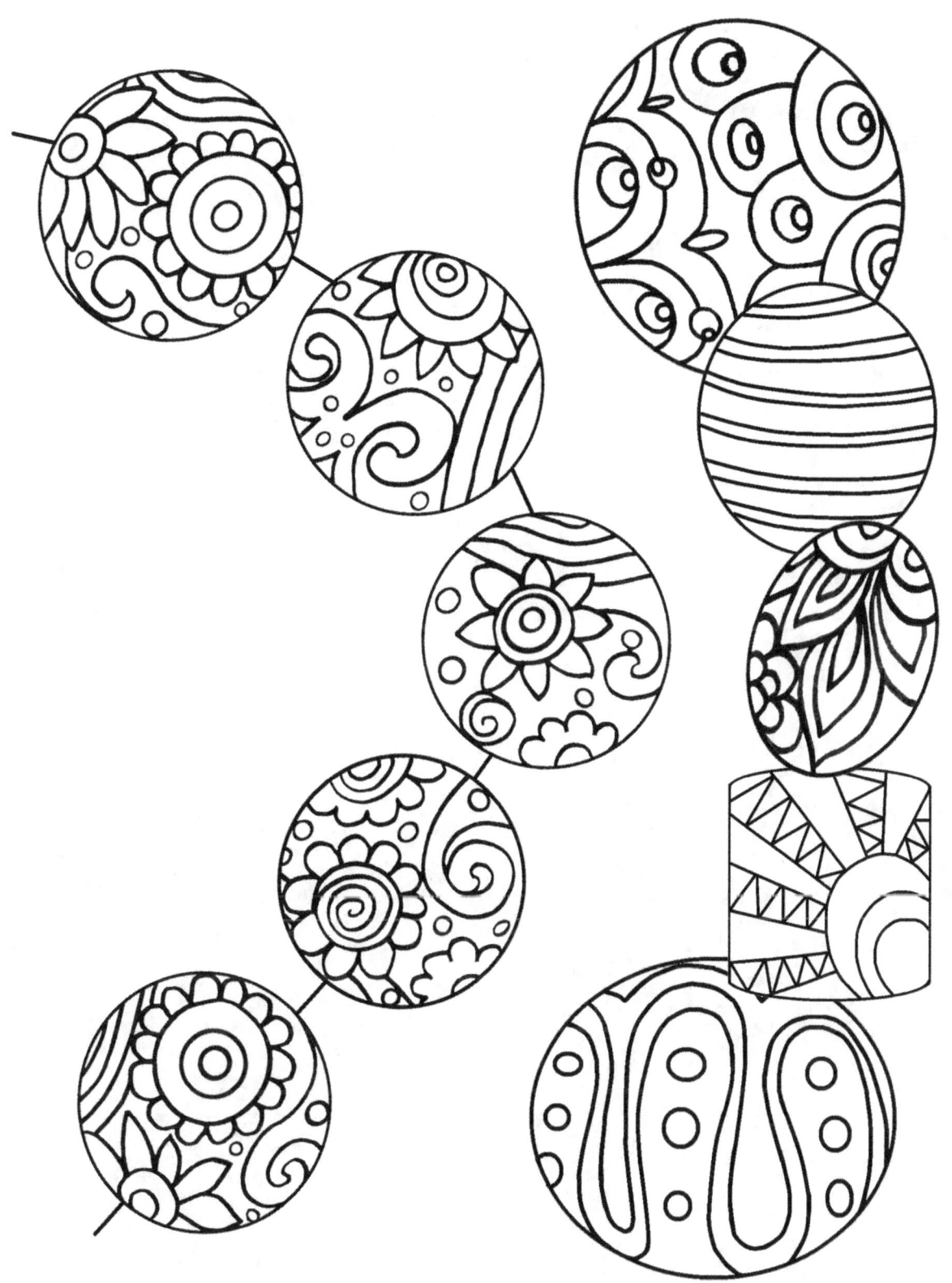

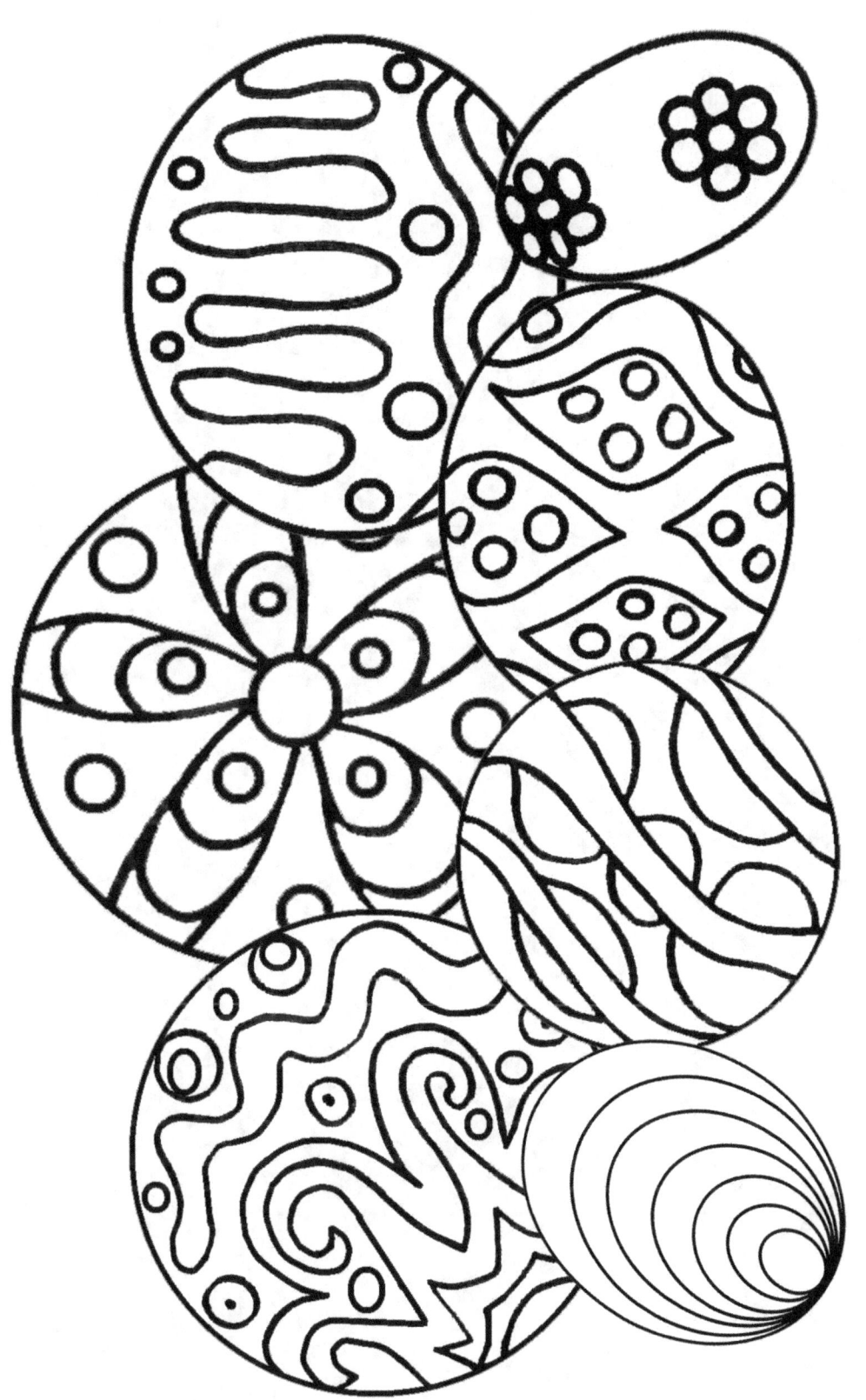

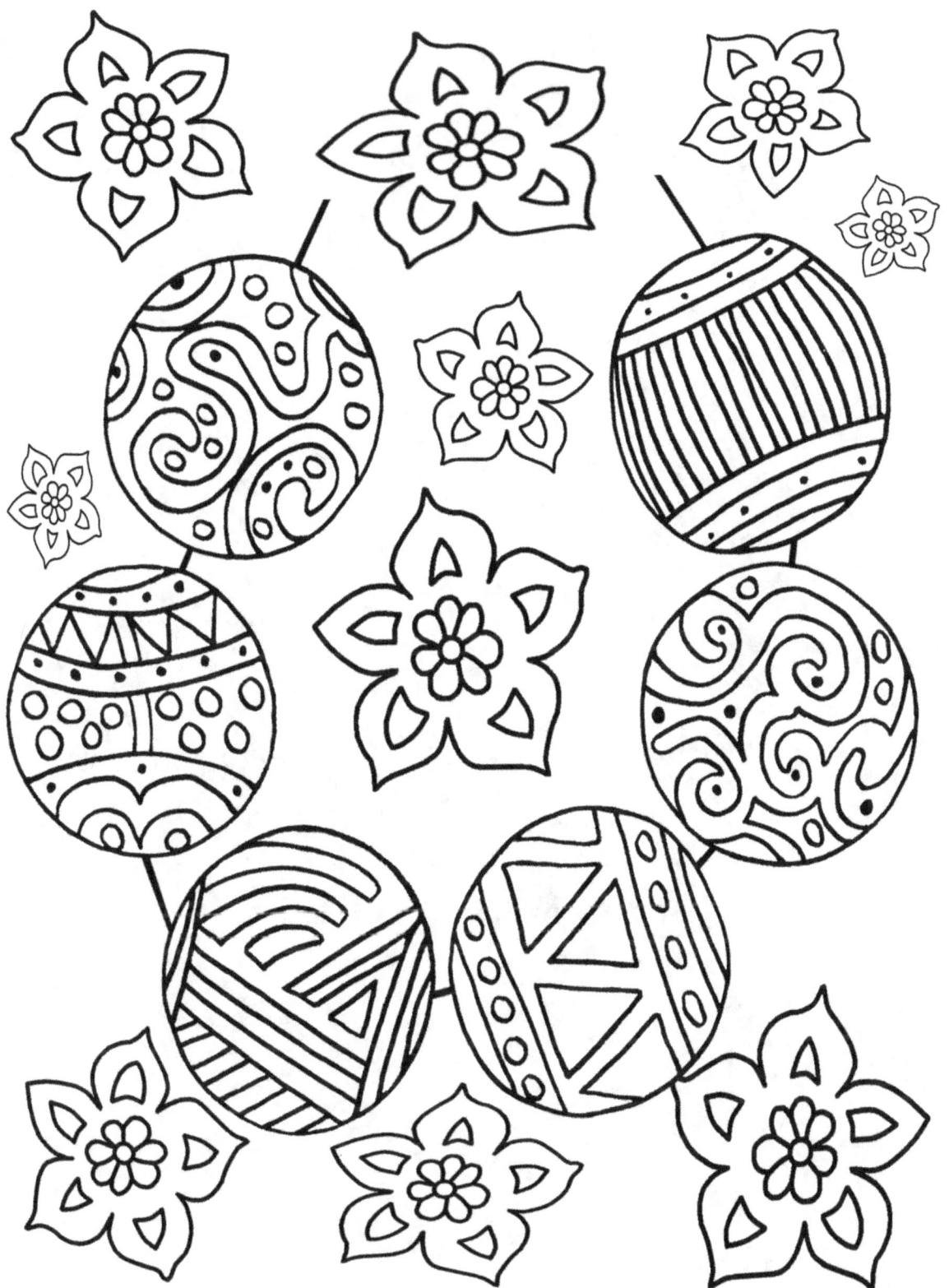

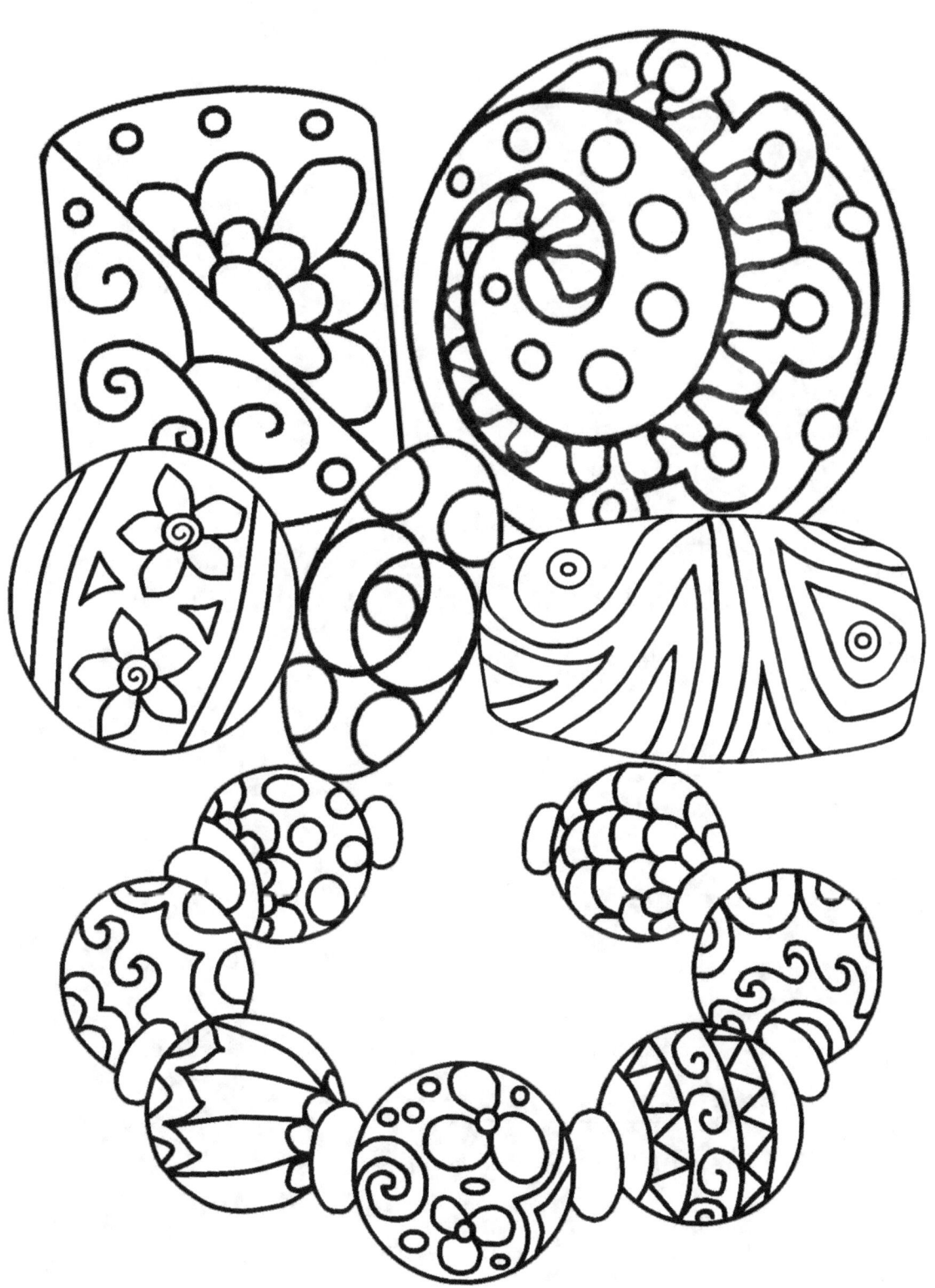

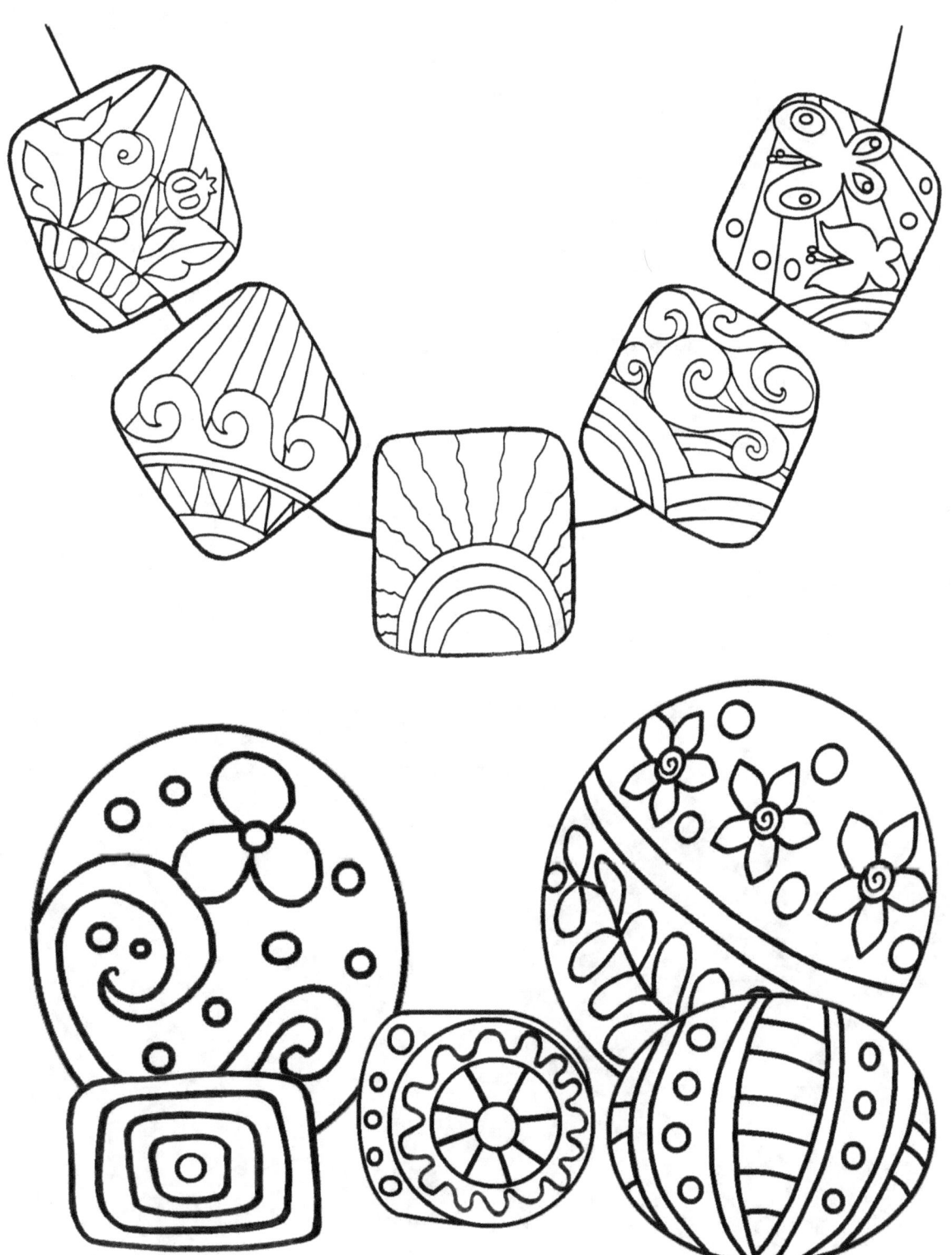

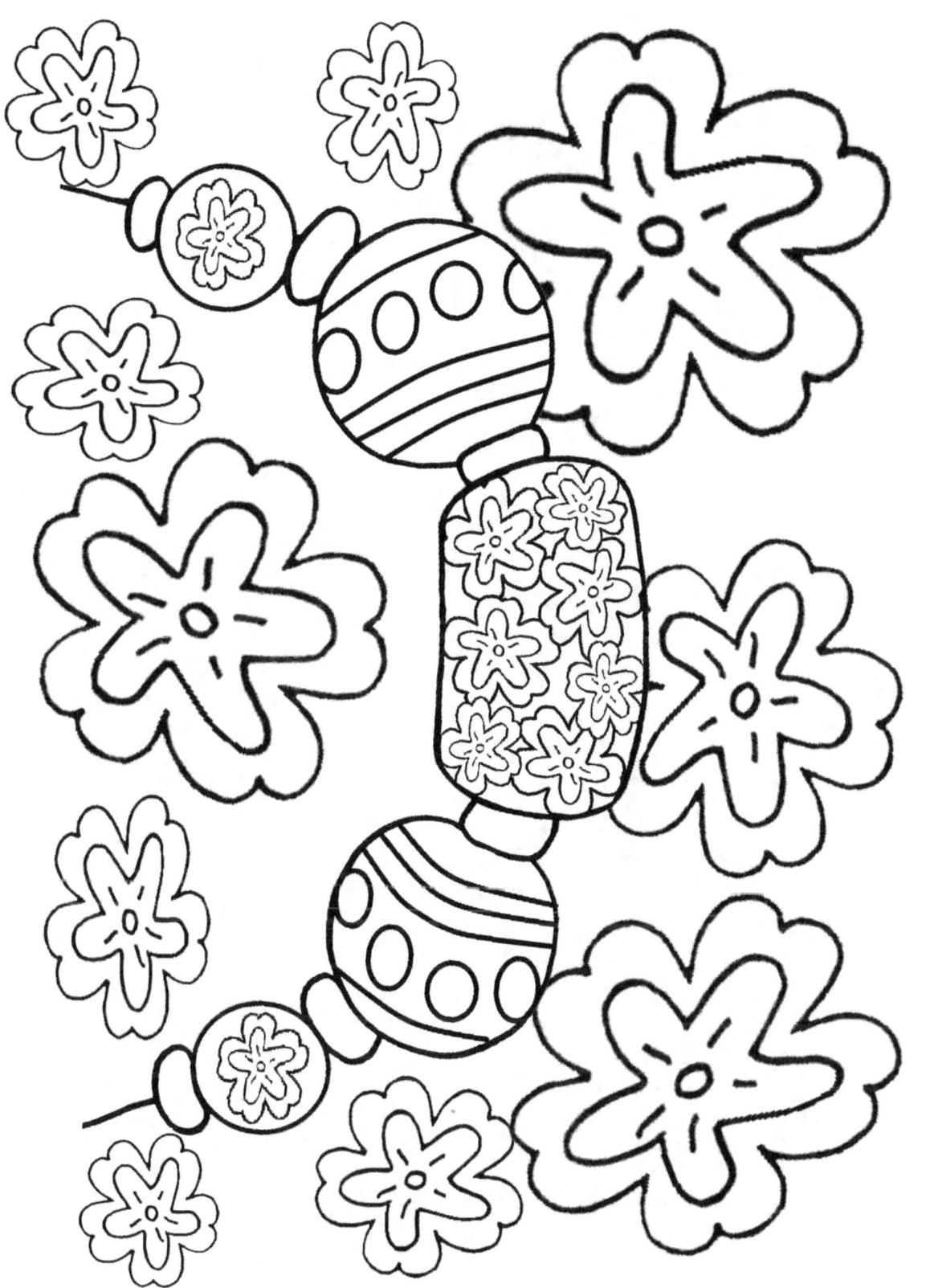

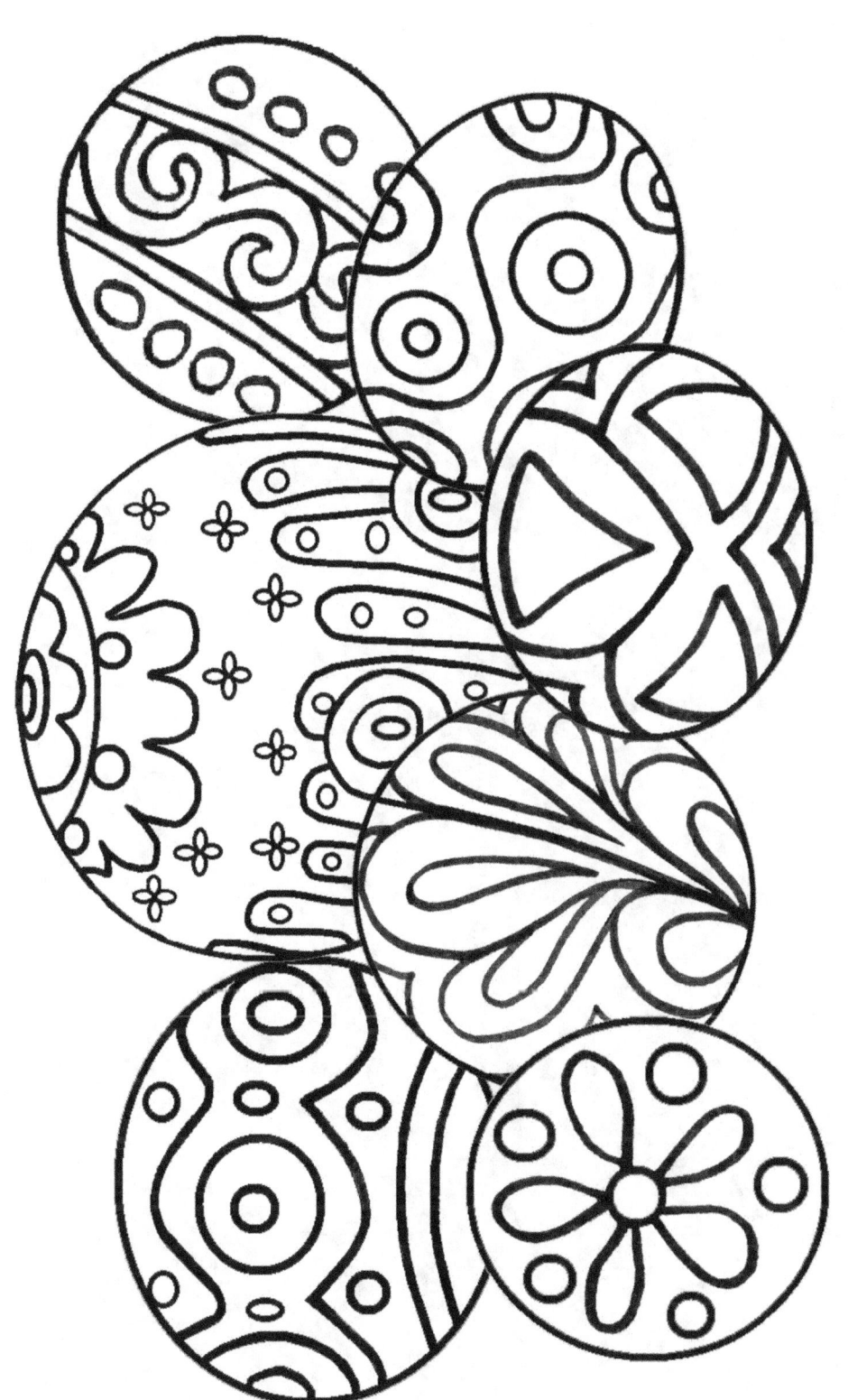

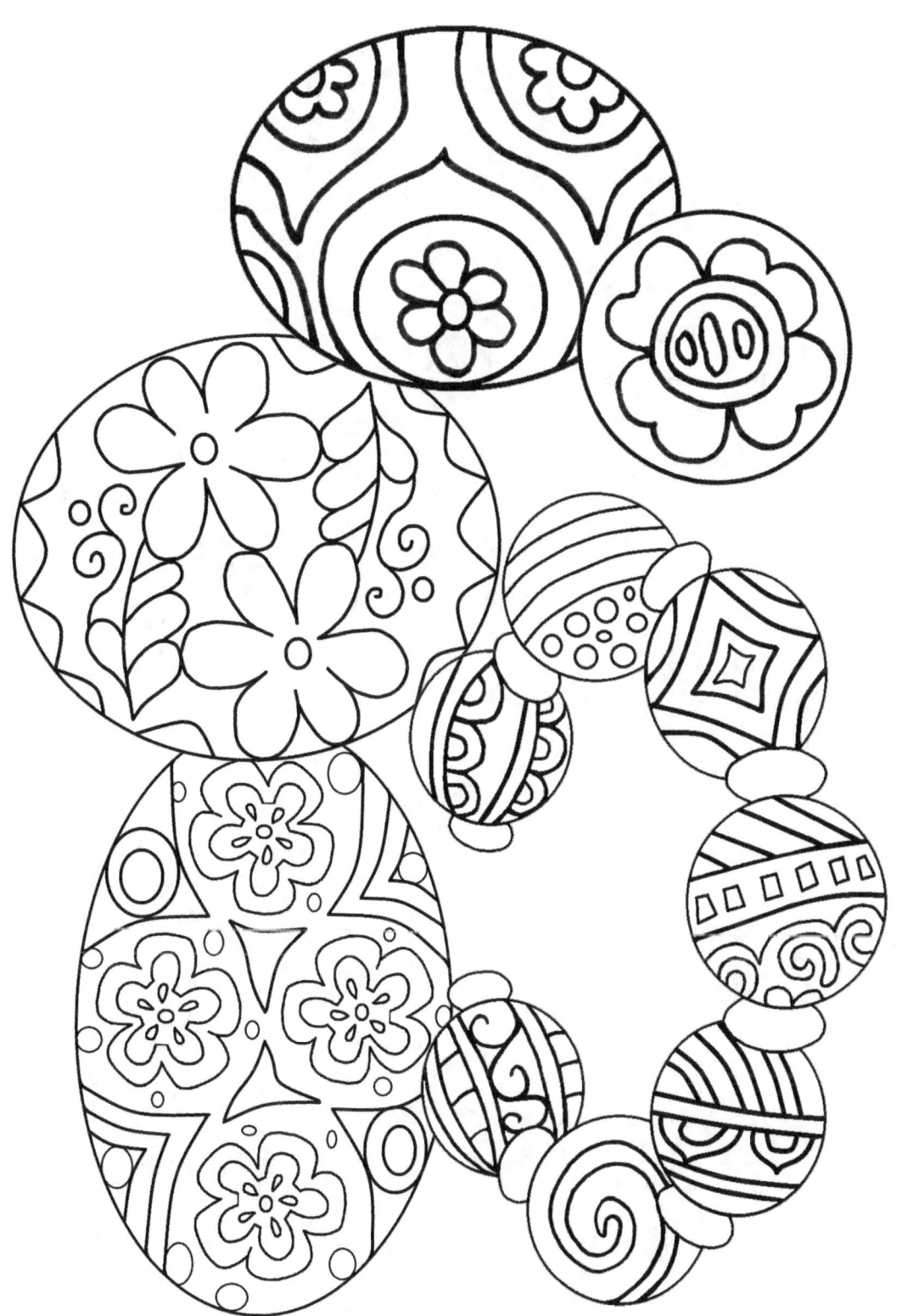

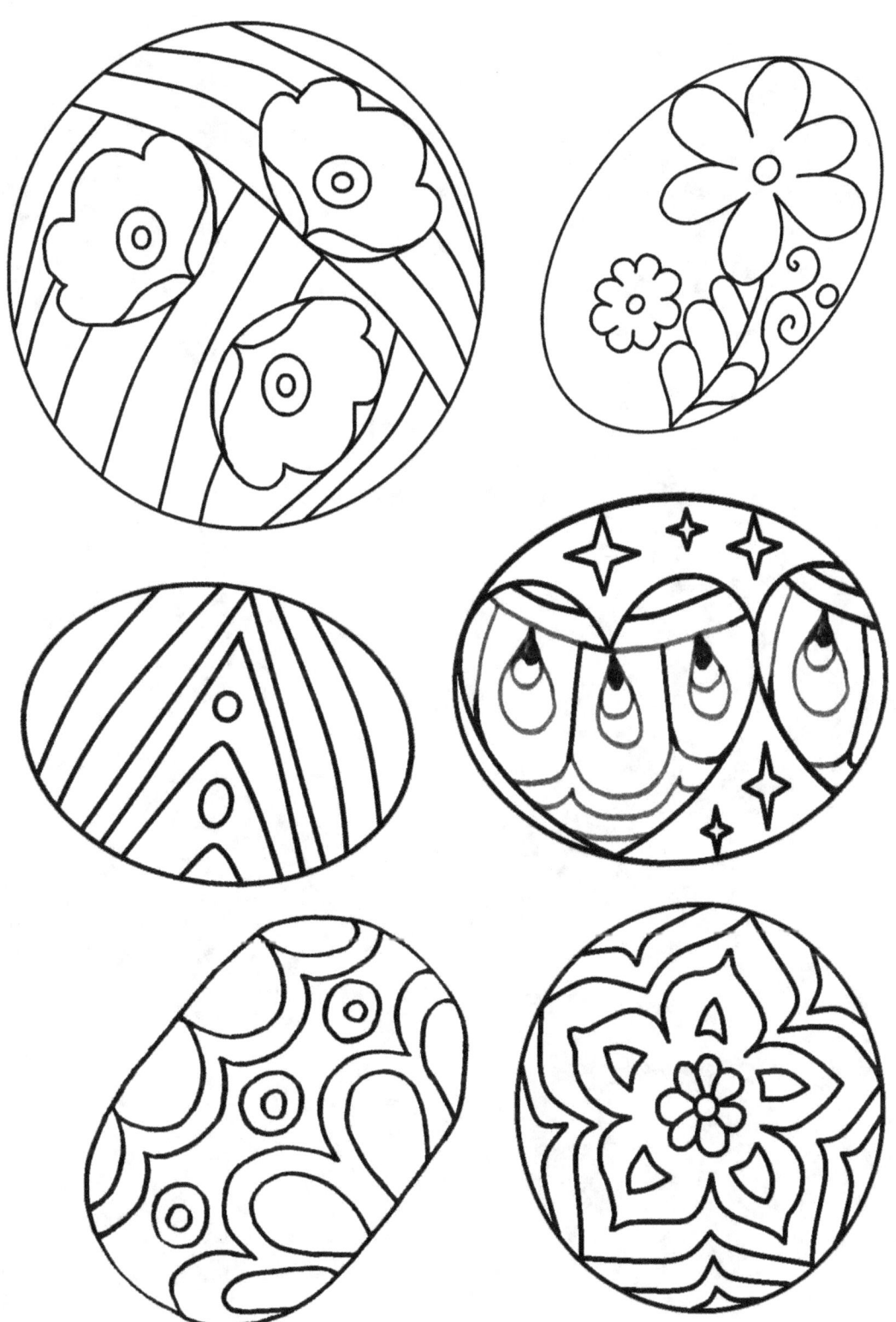

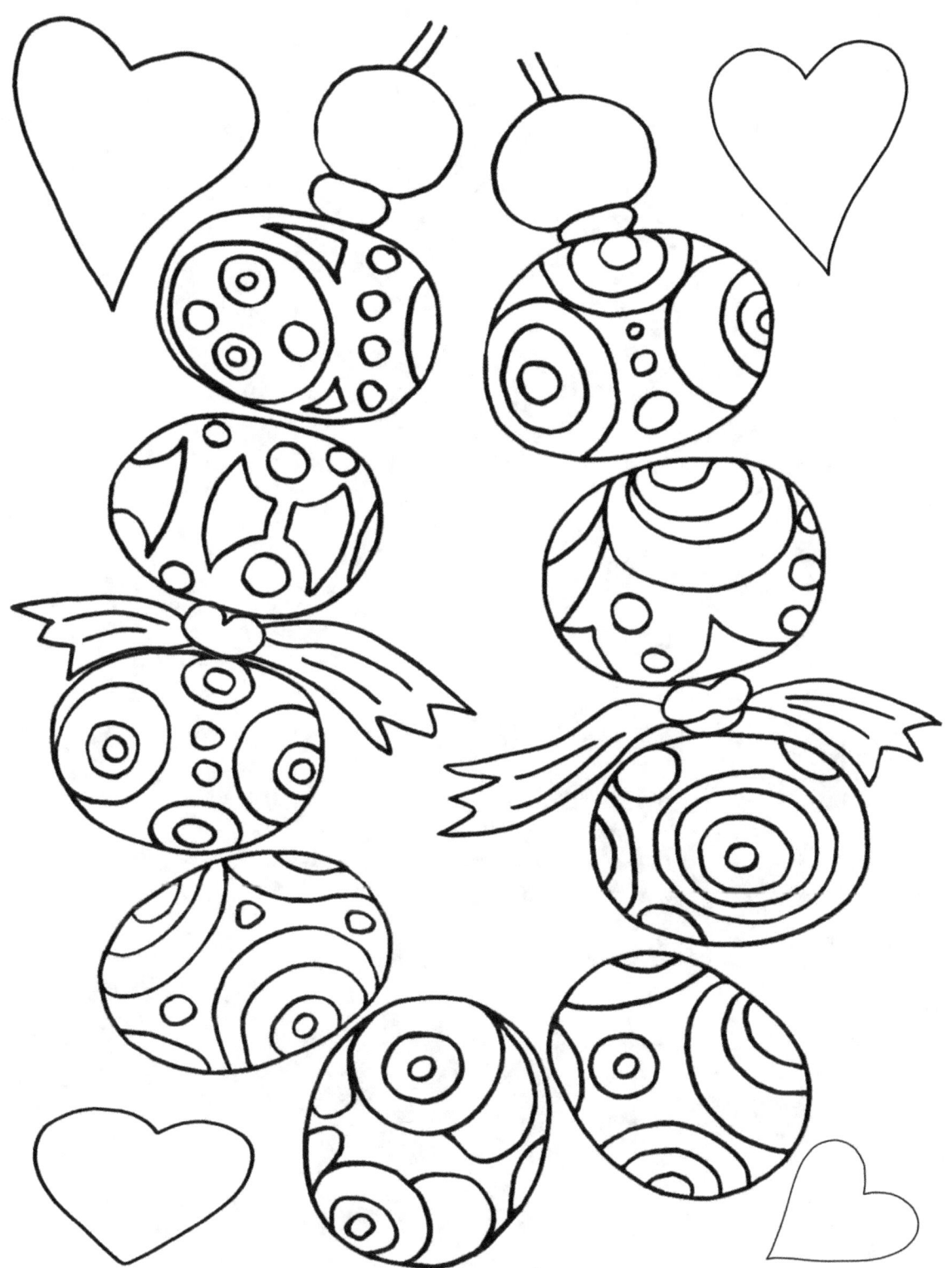

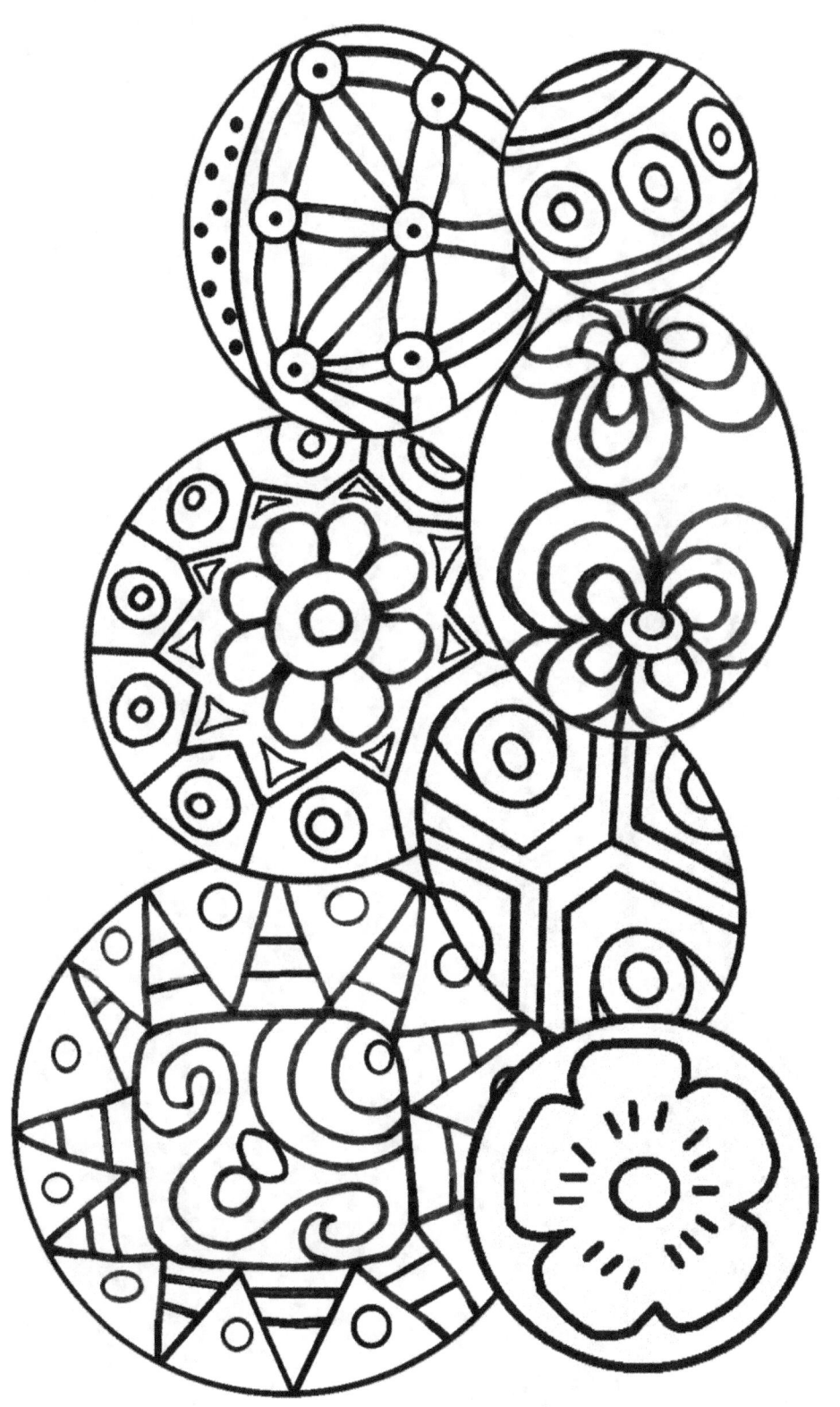

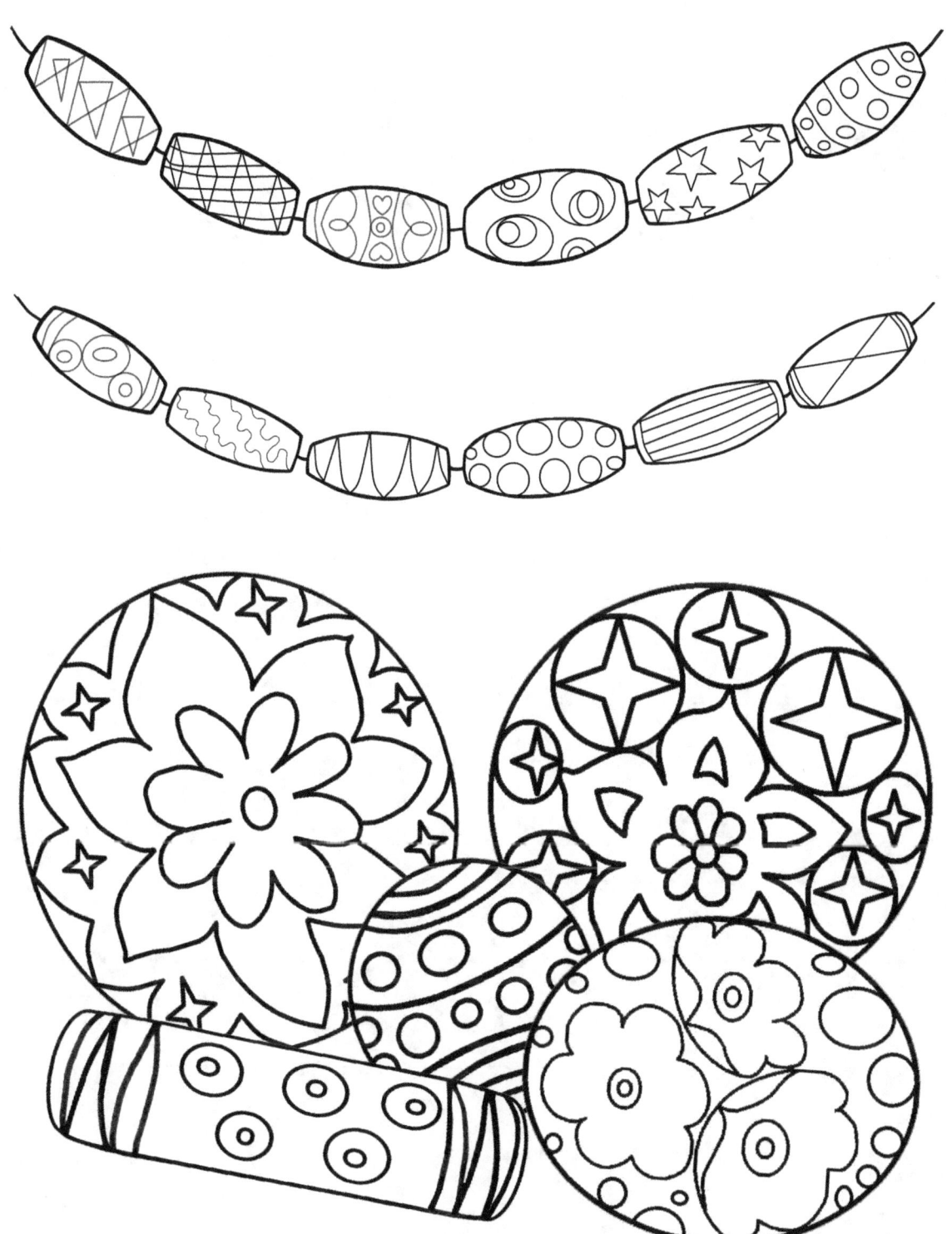

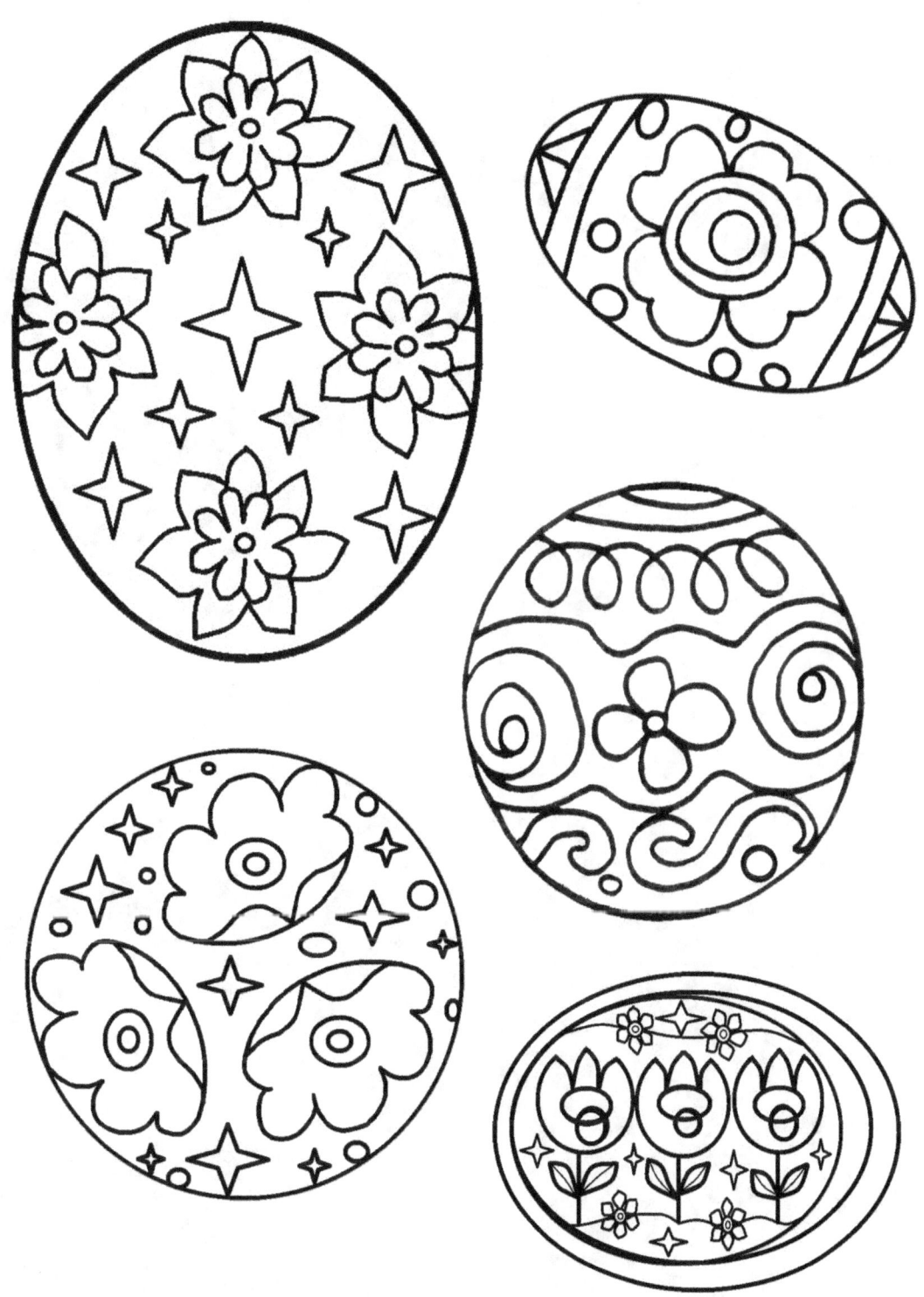

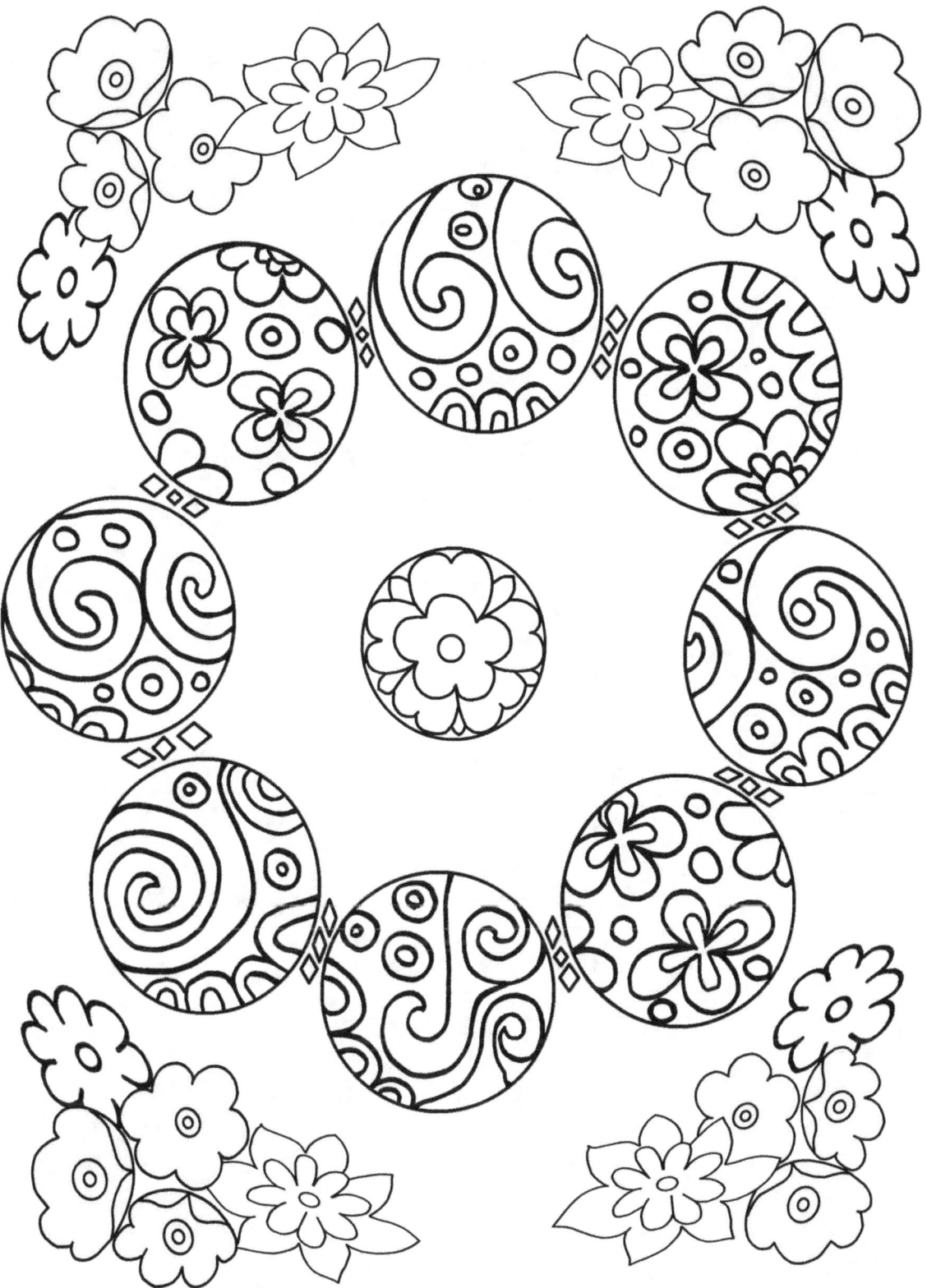

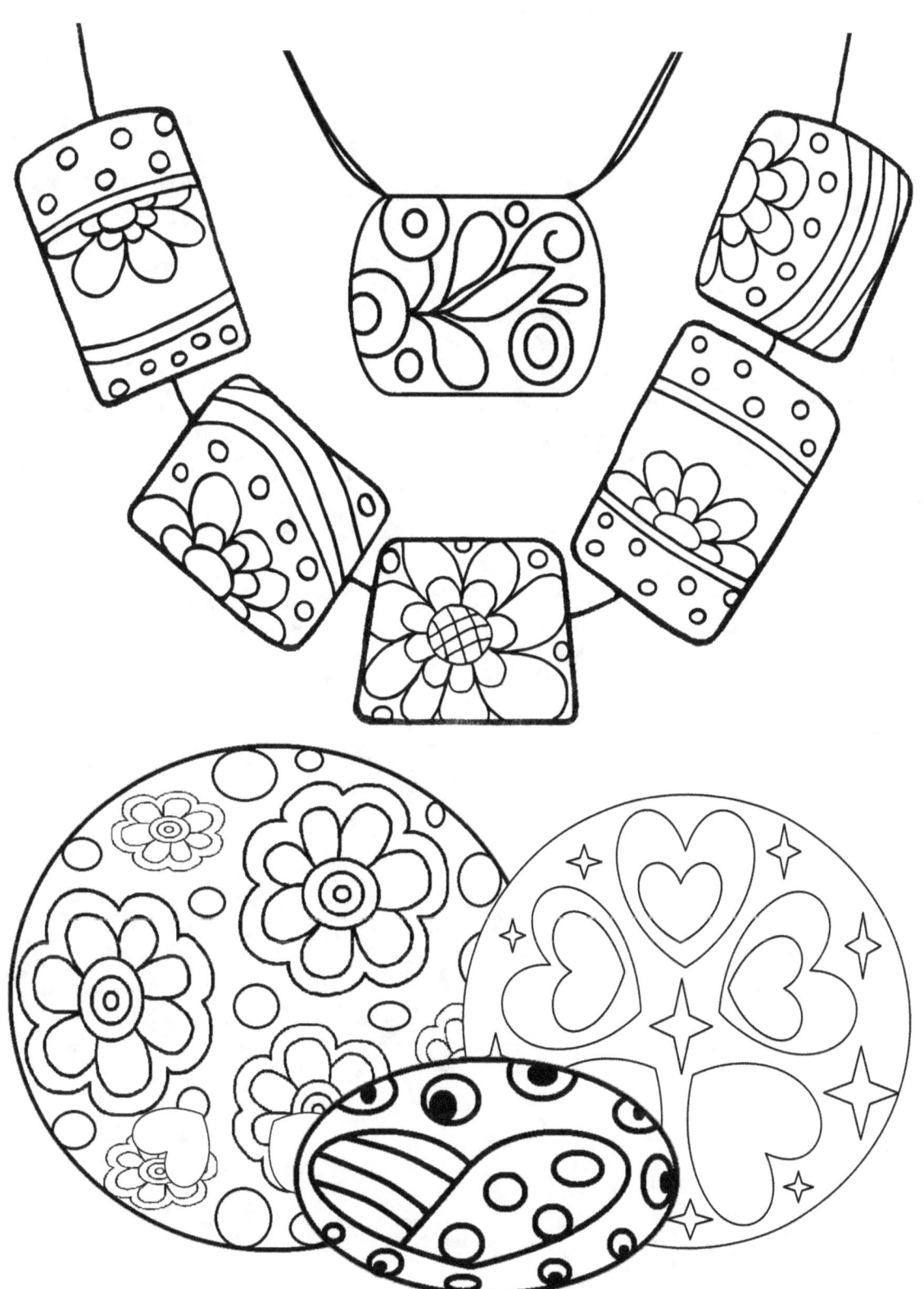

Color Test Page

Color Test Page

Blotting Page

Blotting Page

 ## About the Author

Hi there...

Marigold Fairchild is my artistic pen name. It sounds dreamy and happy like a child under the golden sun on a lovely summer day...because that's what art does in my life, it cheers me up!

Art has been my handkerchief when sad, my relief when stressed, and most time my blessing. Through my Beautiful Beads coloring books, I would love to share that happiness with you, in the purest and simple way. Because for me, art has its highest expression when it improves our life and lifts our spirit.

I also have a quick favor to ask you...

Amazon uses reviews to rank books and many readers evaluate the quality of a title based solely on this feedback from others.

So, if you've enjoyed the Beautiful Bead Coloring Book, **or** even if you're still working through it, could you take a minute or two to leave a review? Even a sentence or two about what you like really helps!

I really appreciate you taking the time to check out the book and I look forward to seeing any feedback you may have in the review section.

Thank you

www.ingramcontent.com/pod-product-compliance
Lightning Source LLC
Chambersburg PA
CBHW081629220526
45468CB00009B/2357